The Coloring Academy

Use the craft of coloring to learn artistic skills such as blending, color theory, skin, hair, and impressionist techniques. Practice on a full collection of beautiful coloring pages, and use these skills in your own art work.

By Jennifer Kozlansky

Cover Art Colorists: Hedy Hsu & Kaytrina Lucas
See more of their work on ColoringUniverse.com

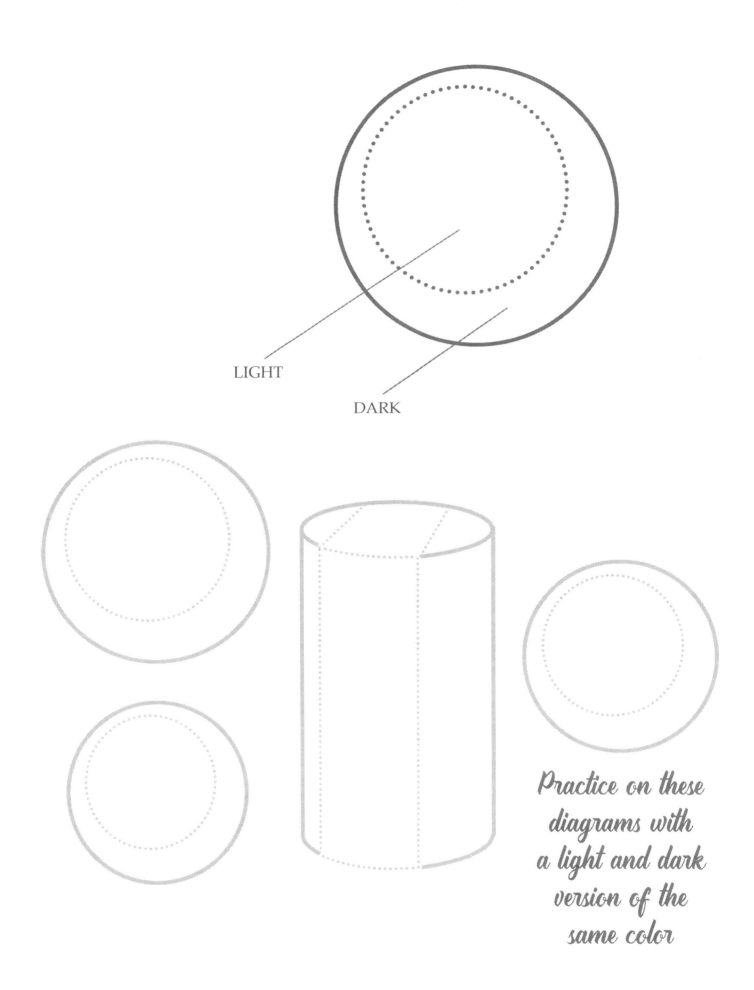

Blending Techniques

BLENDING
One of the first thing a colorist works on is blending - and that's a good thing. Blending is the primary skill that will help your coloring look sophisticated.

SMOOTH OPERATOR
The first step is to know how to create a smooth surface, and banish the 'scribbly' look forever. But how?

TAKE YOUR TIME
Take the time to lay down light layers instead of trying to color as dark as you want it all at once. Pay attention to the point of your colored pencil. If you start very light and create a flat surface on the tip of your pencil, you can use that flat tip for a smooth application.

Without taking care to either apply the color with the flat part of the lead or with a very light hand, you are going to get a 'scribbly' look that will be hard to get rid of once down. So when you take a break or adjust your grip pay attention to how the tip of the pencil is hitting paper before you begin again.

BLENDING TWO COLORS
If you would like a smooth transition from one color to another, be sure to lay down a light layer and keep building on top. If it works with your subject, try blending a neutral color or white for a super-smooth look.

Softer pencils are easier to blend but they will build up material quickly, and all of the sudden you will find it messy - then impossible - to blend. It will take some practice to find a balance with your particular brand of pencils.

For a free video on how to blend check out
The Coloring Academy Page on:

ColoringUniverse.com

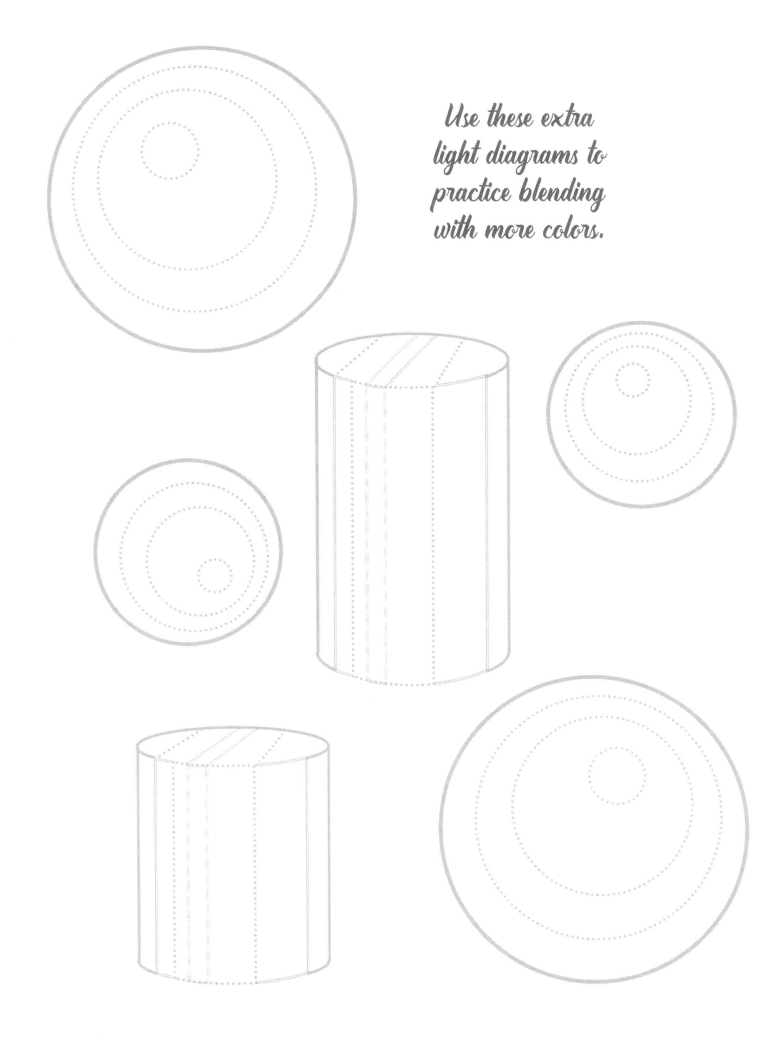

Use these extra light diagrams to practice blending with more colors.

Copyright 2016 Jennifer Kozlansky
Unauthorized reproduction steals from the artist.
Credit **ColoringUniverse.com** when sharing on social media.
Join us on the Coloring Universe Facebook Group!

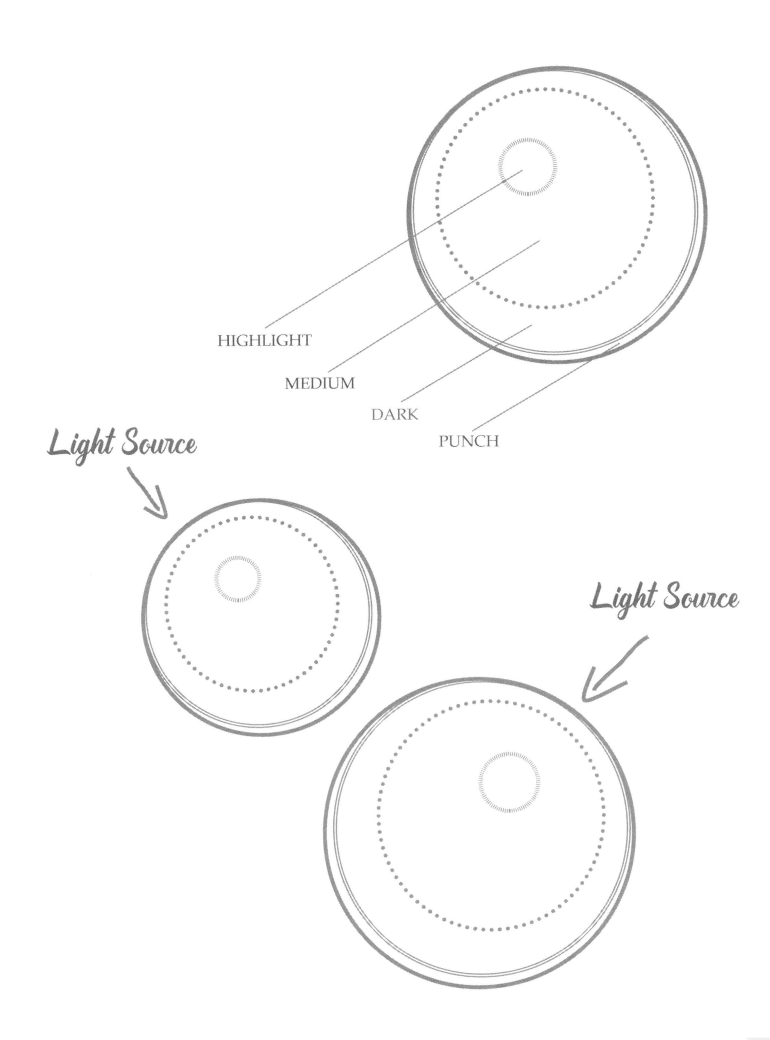

3D Coloring

LIGHT SOURCE
To make your coloring and personal artwork more three dimensional, decide where the light source will come from before you start a new project, and keep it in mind as you work. Use a pencil and draw a very light arrow to indicate where the light is coming from. Then choose shadows and highlights accordingly.

HIGHLIGHT
Look for areas to leave white, or make a dramatically brighter color. Some colorists use a white gel pen or paint on top of a finished work for that extra sparkle. (See the mermaid's tale on the cover of this book.)

PUNCH
In my first year of art school, I learned the word *punch*. How do you add this skill to your coloring and personal artwork?

First, color the entire piece, taking the lights and darks to a comfortable level. Complete the piece.

Take a break, get some tea... With fresh eyes look throughout the piece and choose areas to punch. Any area that seems like it should be the darkest point can be punched.

Scared? Try this! Pick up a colored pencil darker than any you have used so far. Strike a superhero pose... yell *"PUNCH!"* into the room - and go for it.

Start at the very center of the darkest area and blend the color up into the existing shadow. Jump to every area appropriate, taking your coloring to a whole new level.

APPLICATION
Just the angle of your coloring strokes can add a lot of dimension to the work if you are careful to apply them along the natural direction of the object.

Even if the work is subtle and blended, the eye will still sense the direction of the strokes and it will add depth.

Colorist or Superhero?

3D Coloring Diagram

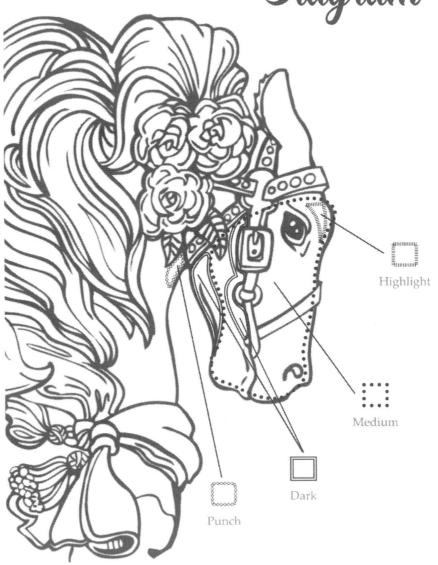

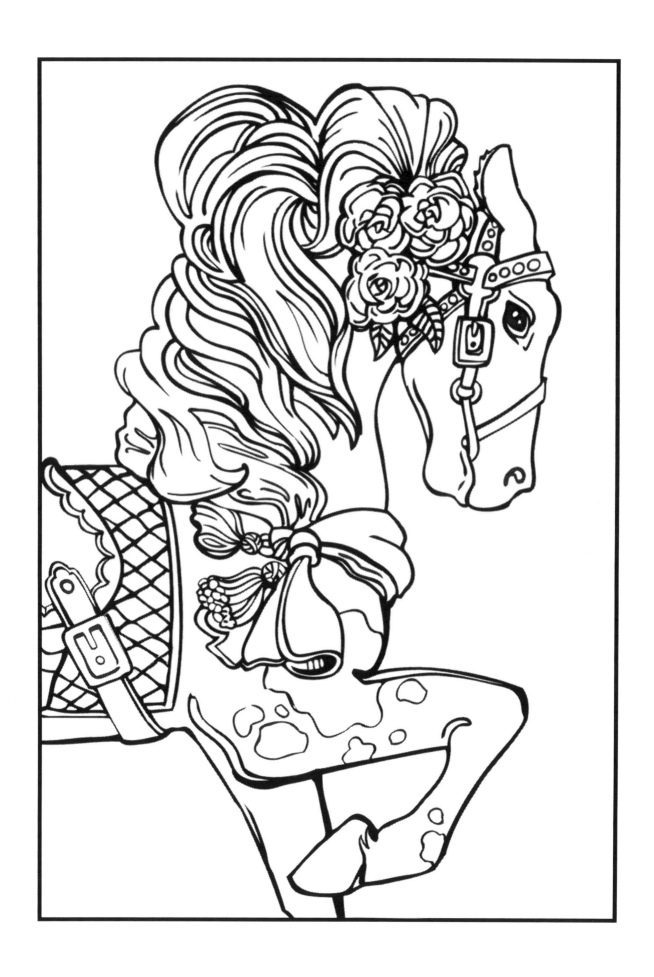

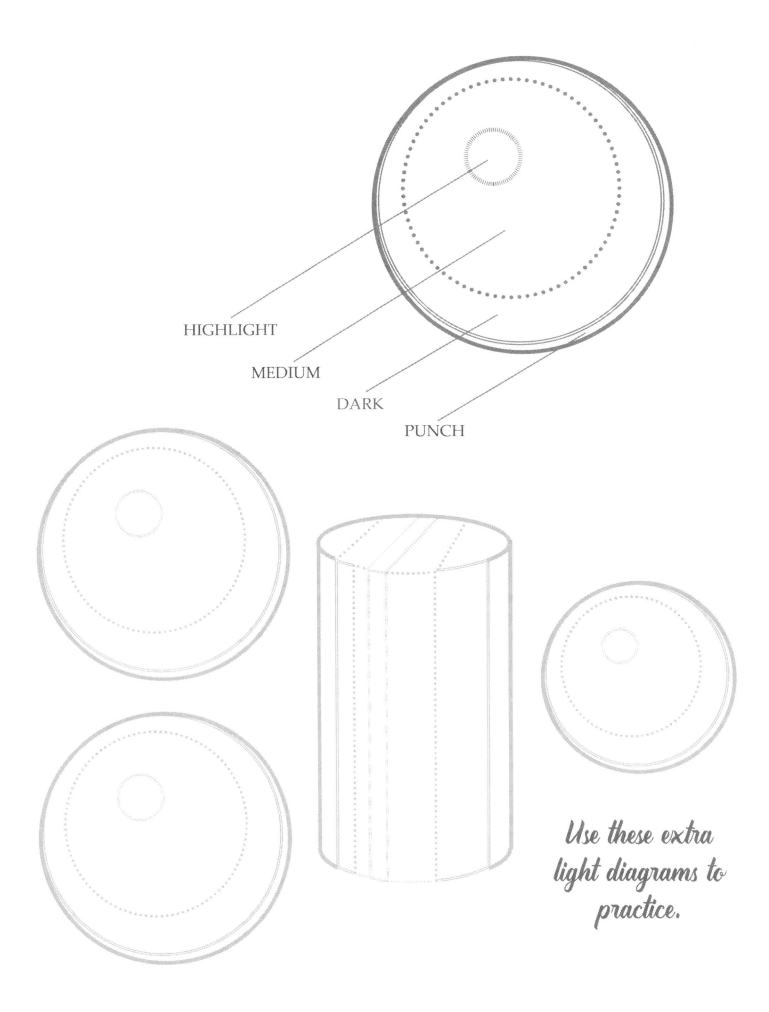

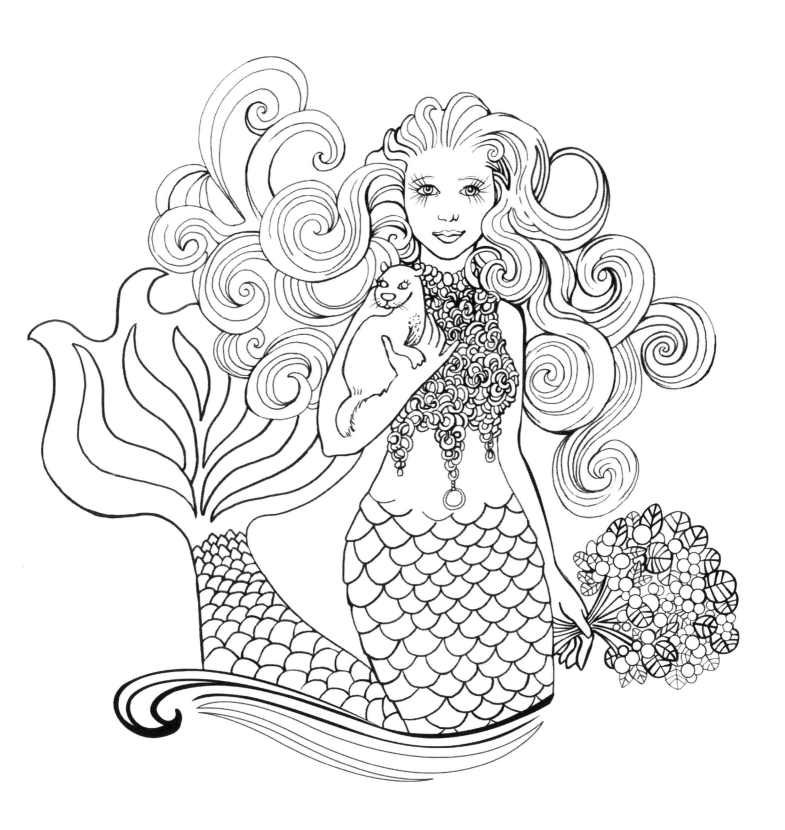

Copyright 2016 Jennifer Kozlansky
Unauthorized reproduction steals from the artist.
Credit **ColoringUniverse.com** when sharing on social media.
Join us on the Coloring Universe Facebook Group!

An Impressionist Technique

VISUAL BLENDING
There are a few ways in which color blends. Sometimes the technique does not involve blending the pigment physically but instead blends visually.

We see this in the glazes of the Renaissance masters - where straight hues are layered on top of one another and colors are blended by the light passing through, hitting the canvas, and bouncing back through the colors at the viewer.

POINTILLISM
With pointillism, it is not the light passing through translucent layers of color, but the proximity of the dabs of pure color that blends them.

For instance, pink and light blue dots of color, applied very close together are visually blended when the eye becomes too far away to see them as separate objects.

IMPRESSIONIST TECHNIQUE
Georges Seurat and Paul Signac developed this technique in 1886. It was part of the Impressionist movement.

Pointillism has a lot of visual energy to it. Because they have never actually been blended, the colors hold their own and fight to be an individual color, creating a unique effect.

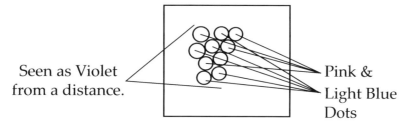

Close up of the pointillism technique. Pure color visually blends when viewed far enough away that eyes can no longer see them individually.

Using pointillism in your next coloring project?

Apply all the colors we talked about in the *Blending* and *Color Theory* section, and instead of blending them, place small dots of color next to each other.

Try it with different media - gel pens markers, colored pencils. Practice here before you begin a piece.

Crosshatching

Crosshatching is another technique in which colors are blended visually rather than physically. Crosshatching will add energy and a modern look to your piece.

The most important thing to keep in mind when trying this technique is to angle the crosshatch strokes so that they make sense with the angle of the surface of the subject.

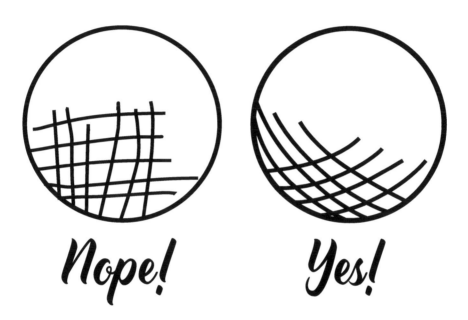

Don't rush this process or you will end up with a mess! By thinking about the angle of the strokes and applying them deliberately and confidently, you will avoid a sloppy look.

Use crosshatching to indicate volume. How? Angle the lines to flow along the object's shape. Do this throughout your whole piece and crosshatching will make your work more three dimensional.

Everything is kinda Crosshatching

When you color anything - with the standard 'back and forth' technique we all use and learned as a child - try to keep in mind the direction of the strokes.

If you think about the angle of the strokes and apply them deliberately and confidently, your coloring will go from child's play, to sophisticated.

Think of the image as a sculpture and 'carve it out' as you go along with the form.

Look at the graphics below. Which one looks more three dimensional?

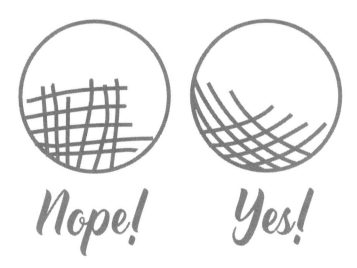

Nope! Yes!

Copyright 2016 Jennifer Kozlansky
Unauthorized reproduction steals from the artist.
Credit **ColoringUniverse.com** when sharing on social media.
Join us on the Coloring Universe Facebook Group!

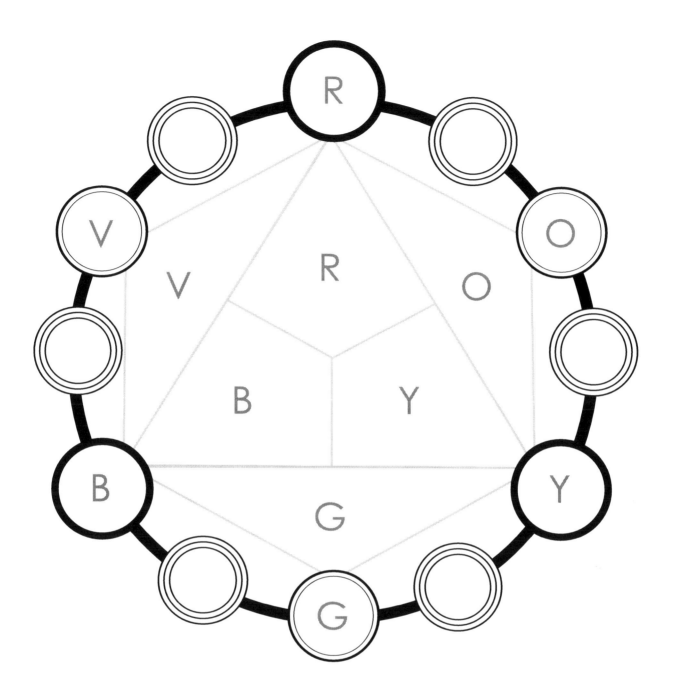

The Colorist's Wheel

Designed by Jennifer Kozlansky

Number of circles indicate type of color.

Once Circle - Primary Color

Two Circles - Secondary

Three Circles - Tertiary Color

ColoringUniverse.com

Copyright 2016 Jennifer Kozlansky
Unauthorized reproduction steals from the artist.
Credit **ColoringUniverse.com** when sharing on social media.
Join us on the Coloring Universe Facebook Group!

Quick Reference Color Composition Sheet

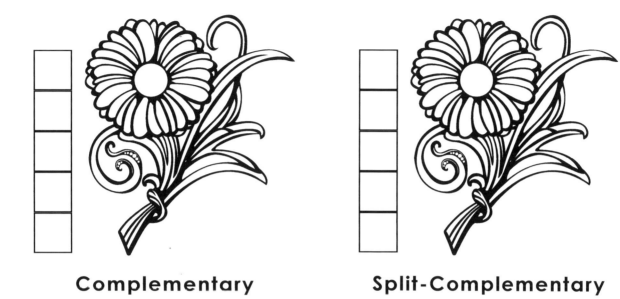

Complementary Split-Complementary

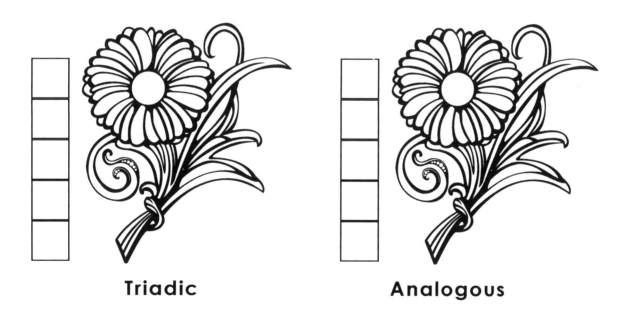

Triadic Analogous

Desk Reference
Compose the four color compositions in the designs above
and use them for a quick reference.

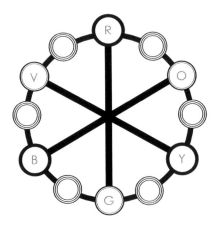

Complementary

Complementary colors live directly across from each other on the color wheel. They are visual opposites. Complementary colors have the ability to affect each other tremendously.

Complementary colors have such a strong affect on your vision that some illusions are based on them. If you look at a red dot for a minute or so and then a white piece of paper, you will see a green dot - its complement. Good times!

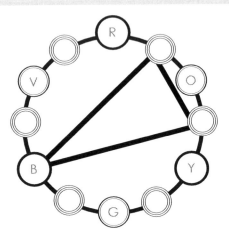

Split-Complementary

Choose one color. Then, instead of using its direct complementary color, choose the colors on either side of that color. Example: Choose blue, then use the colors on either side of orange. (Red-orange and yellow-orange) This creates a balance visually, yet tweaks it for a more surprising result.

You can compose a Double Complementary color scheme by selecting colors on either side of the complement on both sides of the wheel.

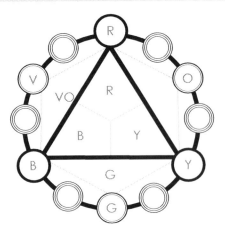

Triadic

A triadic color scheme uses three colors evenly spaced around the color wheel. Triadic color compositions tend to be as bright and happy as a summer's day and just as happily balanced.

It is best to choose one color to predominate. How? If you want to keep the whole piece vibrant, then cover more area on your coloring page with the dominate color and cover less with the others while keeping all three colors vibrant. Or keep one color vibrant and use less saturated or 'grayed-out' colors for the other two choices.

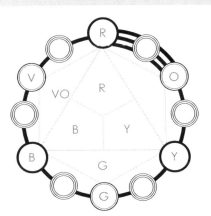

Analogous

Analogous color schemes are found next to each other on the color wheel. It may sound limiting at first but if you want your finished piece to be soothing and serene, this is a great choice. This composition is often found in nature. Think of a forest scene with shades of green. It tends to stay between yellow-green and blue-green. This composition is harmonious and pleasing to the eye and it is remarkable how visually powerful that kind of harmony can be on a coloring page.

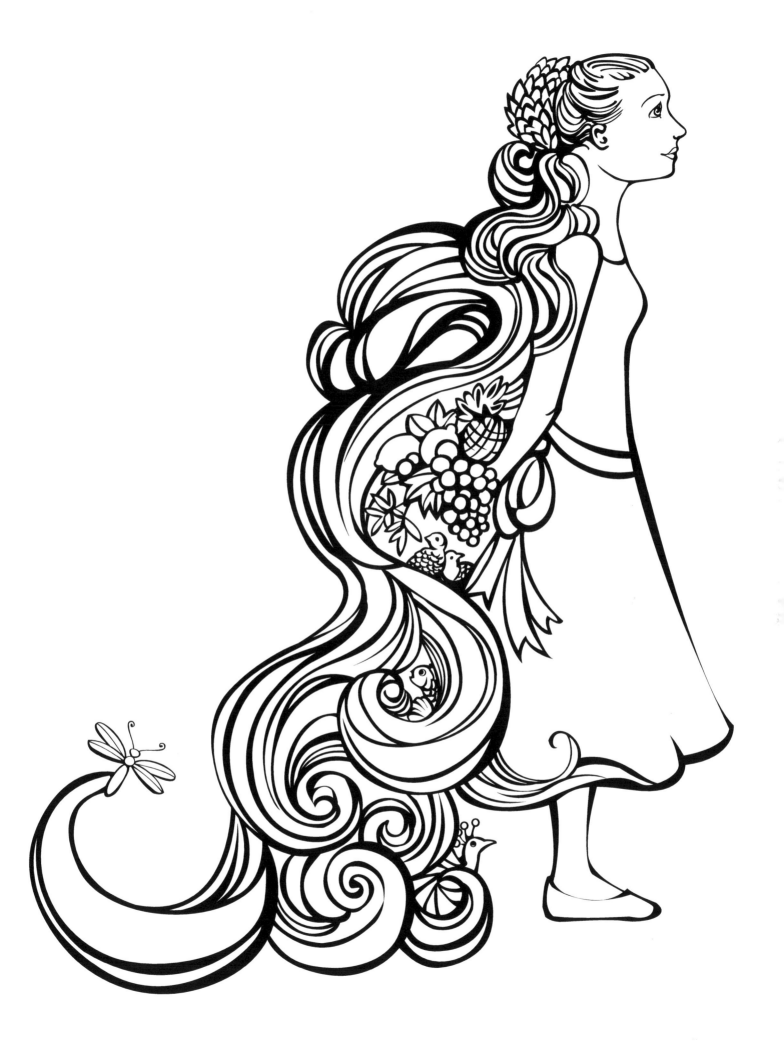

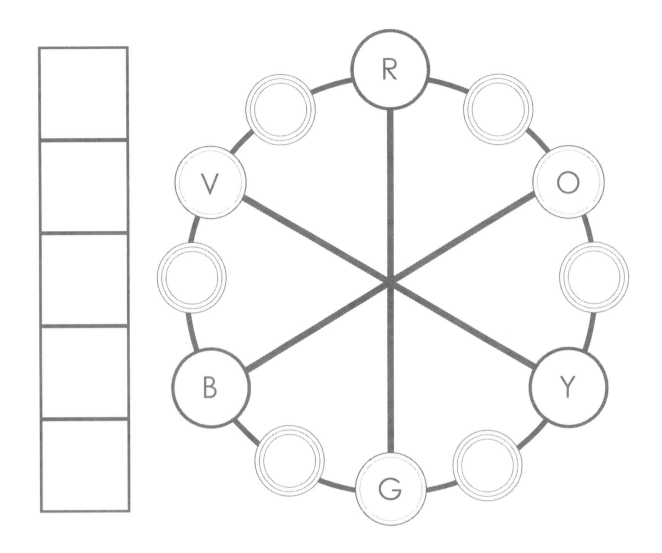

Complementary

Colors used: _____

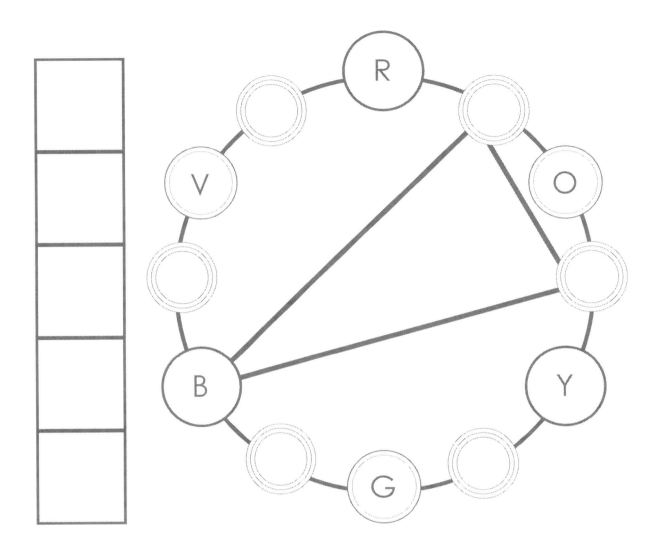

Split Complementary

Colors used: _____

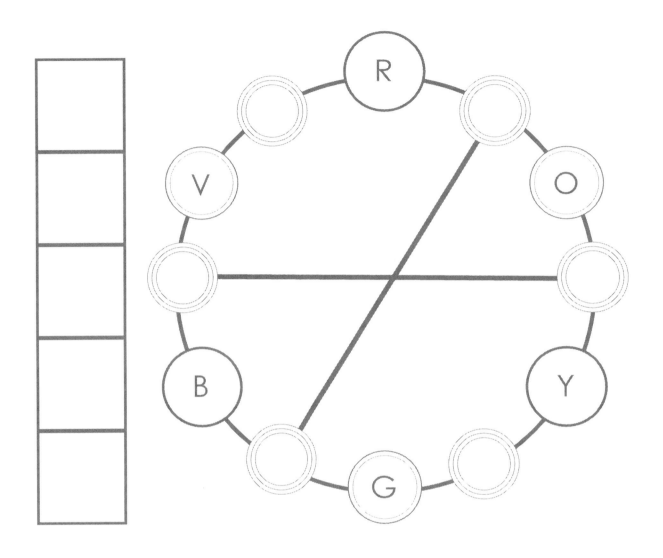

Double Complementary

Colors used: _____

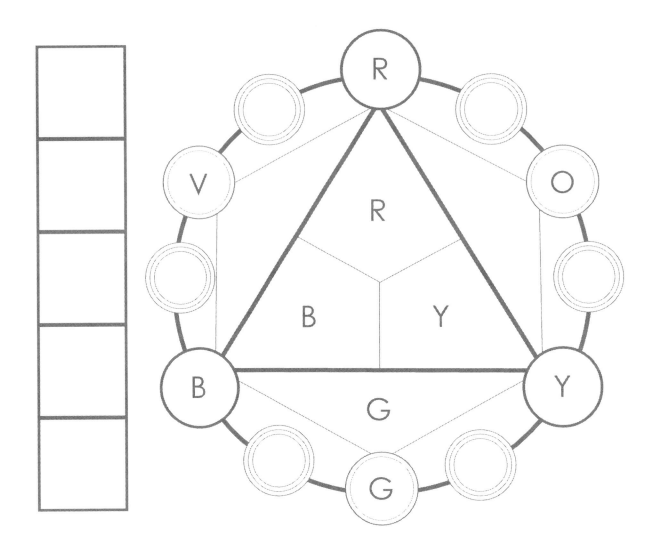

Triadic

Colors used: _____

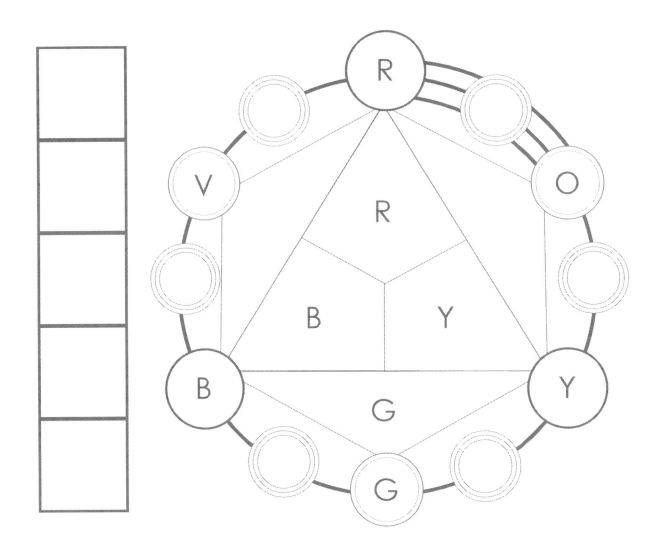

Analogous

Colors used: _____

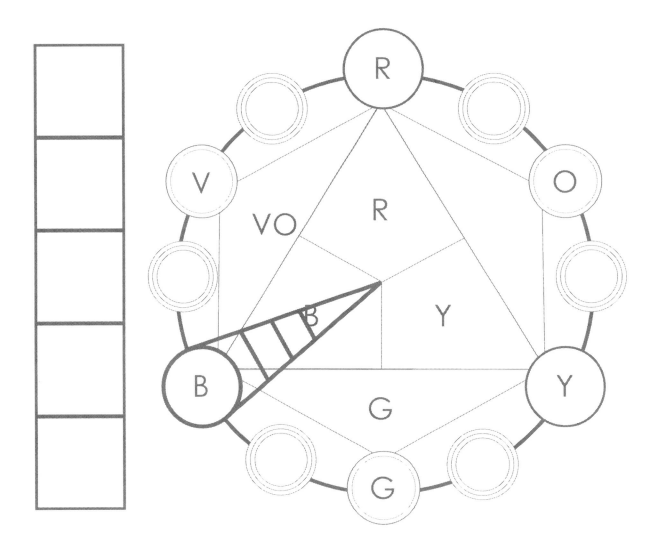

Monochrome

Shades Used: _____

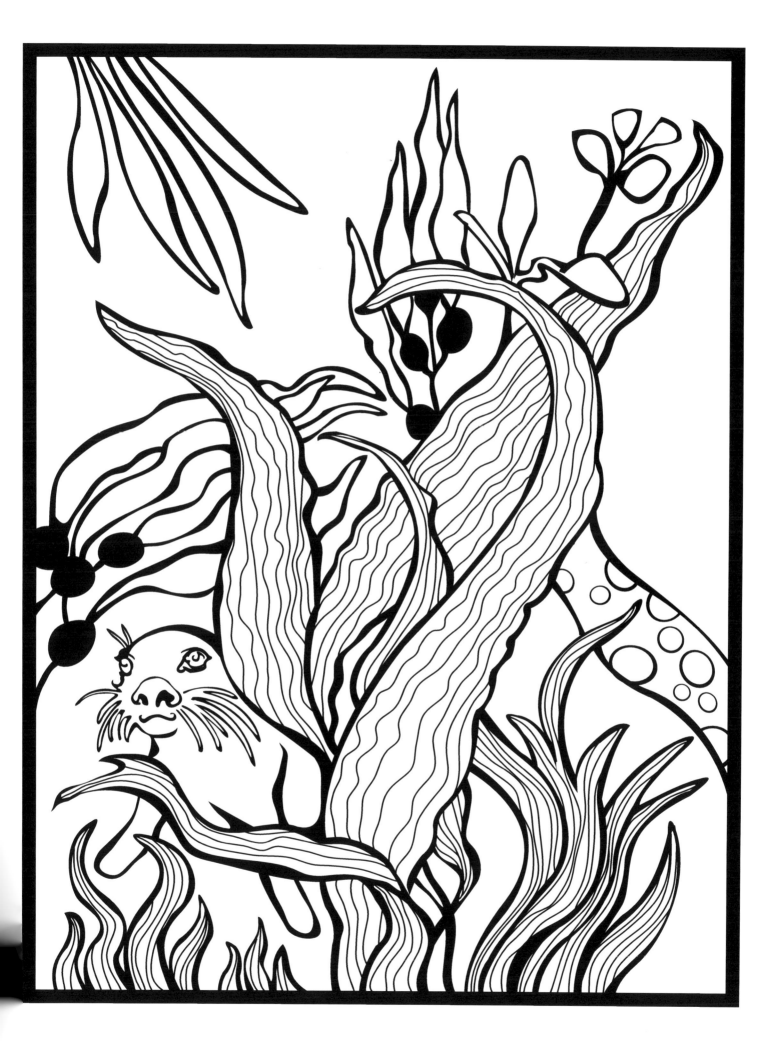

Copyright 2016 Jennifer Kozlansky
Unauthorized reproduction steals from the artist.
Credit **ColoringUniverse.com** when sharing on social media.
Join us on the Coloring Universe Facebook Group!

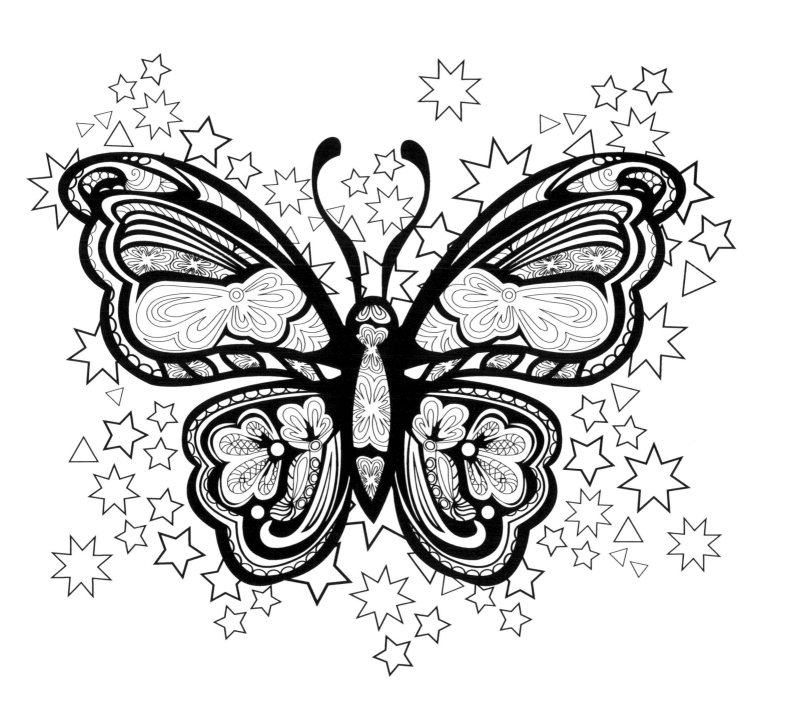

Coloring Universe

Copyright 2016 Jennifer Kozlansky
Unauthorized reproduction steals from the artist.
Credit **ColoringUniverse.com** when sharing on social media.
Join us on the Coloring Universe Facebook Group!

Skin Tones

You can color skin with just one color, but if you want to learn to do natural tones with nuanced visual interests, skin tones require the blending of colors.

CHOOSE YOUR COLOR
Start with three colors. 1) A *base color* that you will lightly fill in the whole area, avoiding the highlights. 2) A *glowy color* (obviously, these are highly technical terms) that will be slightly darker and add a glow to the mid tones. 3) The *shadow* color. Before you begin, think about the light source and plan areas for your *highlight* color accordingly. Add the *punch* color at the very end.

WARM & COOL
The predominate colors you will choose will be warm. Even a cool skin tone is an overall warm color, so the term 'cool skin tone' has more to do with picking up some cooler tones in the shadows, or choosing a cooler pink, like magenta as opposed to an orange-ish pink, which is a warmer color.

Avoid using black for general shading, blend a darker color instead. Look at the worksheets on the following six pages for suggestions on specific colors. Use the individual colors more or less to get different looks. *Colors on the worksheets are given the most general name possible so you can find the corresponding color in your personal colored pencil set.*

BECOME AN ARTIST
No one walks around with hot pink or purple in their skin... Or do they? If you look closely, and with an artistic eye, you can see rich purple tones in someone with very dark skin and you can see blue tones in someone with light skin. Push that phenomenon when you color for visual interest.

For instance, you may try a violet for darker skin, or a cool blue (cerulean, aquamarine) for lighter skin, and a clear green for olive based skin.

For inspiration, look at Renoir - his portraits often showed bright blues and pinks in his subjects. That is the beauty of being an artist - you have the power to take subtle notes found in nature and express them boldly to the world.

Grab a test sheet — try your own colors!
Use in your own artwork . . .

Deep Warm Tones

Base: Sienna Brown

Glowy: Peach

Shadows: Dark Brown

Highlight & Punch — Cream / Dark Umber

Visual Interest Tip:

Blend at least the colors above as a basic step to avoid a uniform 'housepaint' look. This skin tone has a reflective quality to it - so think about texture and plan your highlights. Bright oranges and rich reds can be your surprising visual notes, and add depth and a ton of visual interest.

Try your own colors!

Base: _____

Glowy: _____

Shadows: _____

Deep Cool Tones

Base: Dark Umber

Glowy: Violet

Shadows: Darkest Blue

Highlight & Punch

Light Silver / Black

Visual Interest Tip:

How great is a skin tone when the color Violet works as a predominant color? This skin tone also has an incredible sheen to it, so think about texture and let that highlight be dramatic! Strictly avoid any color with a milky/opaque pigment. Have fun adding rich purples into the shadows and magentas into the mid-tones for depth and visual reward.

Try your own colors!

Base: _____

Glowy: _____

Shadows: _____

Light Cool Tones

Base: Peach

Glowy: Pink

Shadows: Sienna

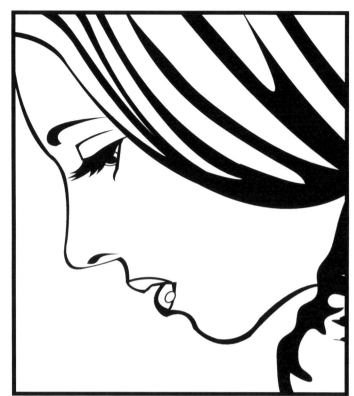

White / Blue

Visual Interest Tip:

Play around with surprising colors with this one - with a light hand you can even make cerulean blue, magenta (cool pinks) and purples and greens realistic as long as you balance them and blend with the base color. Apply these dramatic colors heavily in either a limited or widespread area for an abstract approach.

Try your own colors!

Base:

Glowy:

Shadows:

Light Warm Tones

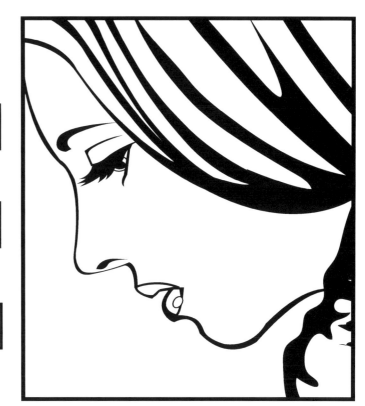

Base: Beige

Glowy: Peach

Shadows: Sienna Brown

White / Dark Umber

Visual Interest Tip:

Warm Light tones can have bright oranges and cool greens introduced lightly and blended with the base color for a realistic look - or try a more bold application of those colors with pointillism, or an exaggerated crosshatch pattern for dramatic flair. Use the boxes and sample image to try it out!

Try your own colors!

Base: _____

Glowy: _____

Shadows: _____

Medium Warm Tones

Base: Peach

Glowy: Yellow Ochre

Shadows: Sienna Brown

Highlight & Punch
Cream / Dark Brown

Visual Interest Tip:

Be generous with the Sienna Brown and use more or less to give variety to this tone. Medium Warm tones can have warm oranges and bright greens introduced lightly and blended with the base color for a realistic look, or try a more bold application of those colors with pointillism, or an exaggerated crosshatch pattern for dramatic flair. Use the boxes and sample image to try it out!

Try your own colors!

Base: _____

Glowy: _____

Shadows: _____

Medium Cool Tones

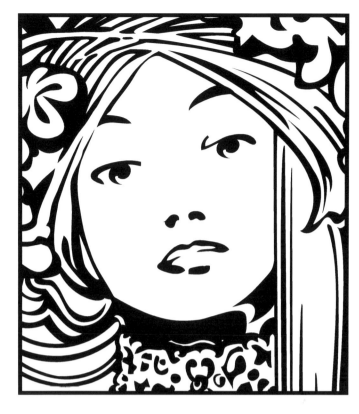

Base: Peach

Glowy: Yellow Ochre

Shadows: Sienna Brown & Lime Green

Highlight & Punch

Cream / Light Umber

Visual Interest Tip:

Try blending Sienna and Lime Green together into the shadows. Cool Medium tones can have bright yellows and cool greens introduced lightly and blended with the base color for a realistic look, or try a more bold application of those colors with pointillism, or an exaggerated crosshatch pattern for dramatic flair. Use the boxes and sample image to try it out!

Try your own colors!

Base: _____

Glowy: _____

Shadows: _____

Copyright 2016 Jennifer Kozlansky
Unauthorized reproduction steals from the artist.
Credit **ColoringUniverse.com** when sharing on social media.
Join us on the Coloring Universe Facebook Group!

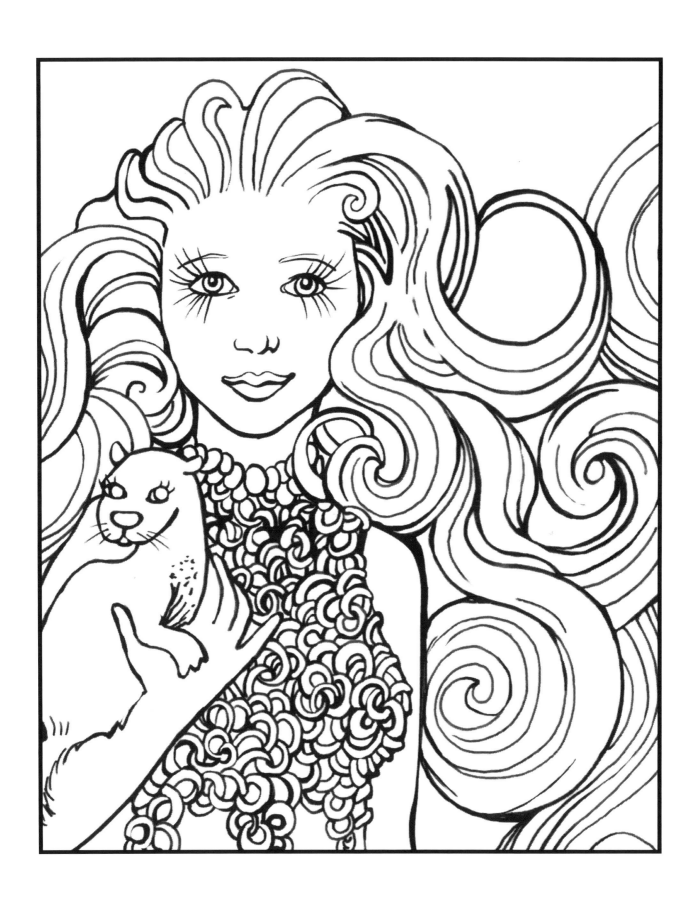

Copyright 2016 Jennifer Kozlansky
Unauthorized reproduction steals from the artist.
Credit **ColoringUniverse.com** when sharing on social media.
Join us on the Coloring Universe Facebook Group!

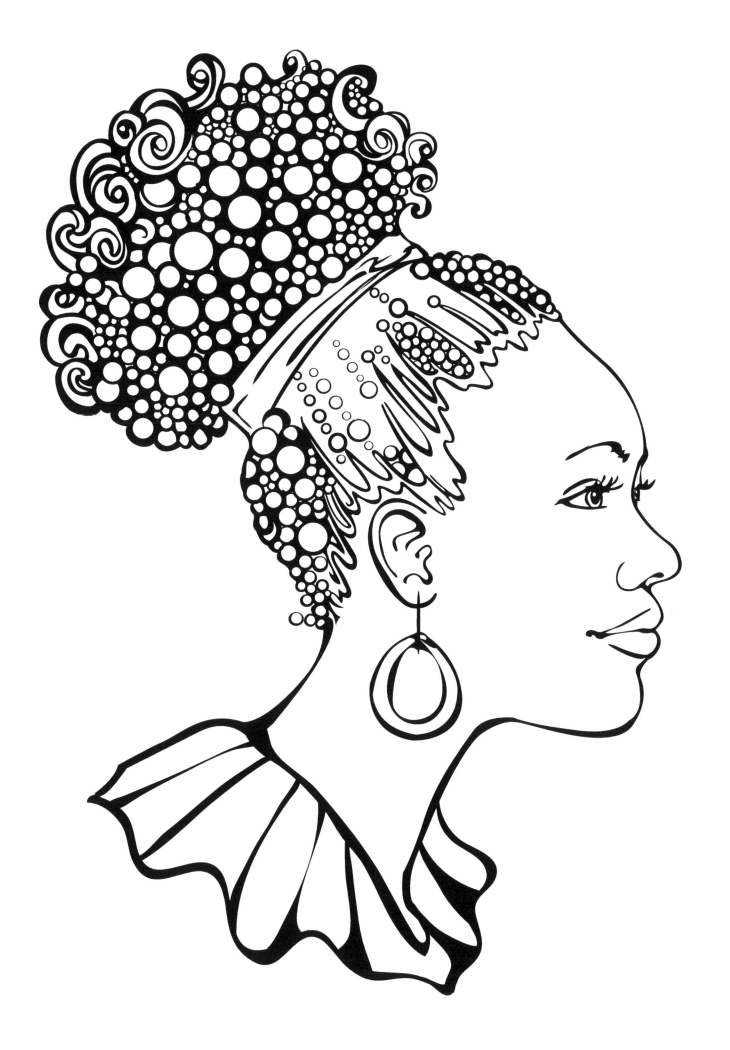

Copyright 2016 Jennifer Kozlansky
Unauthorized reproduction steals from the artist.
Credit **ColoringUniverse.com** when sharing on social media.
Join us on the Coloring Universe Facebook Group!

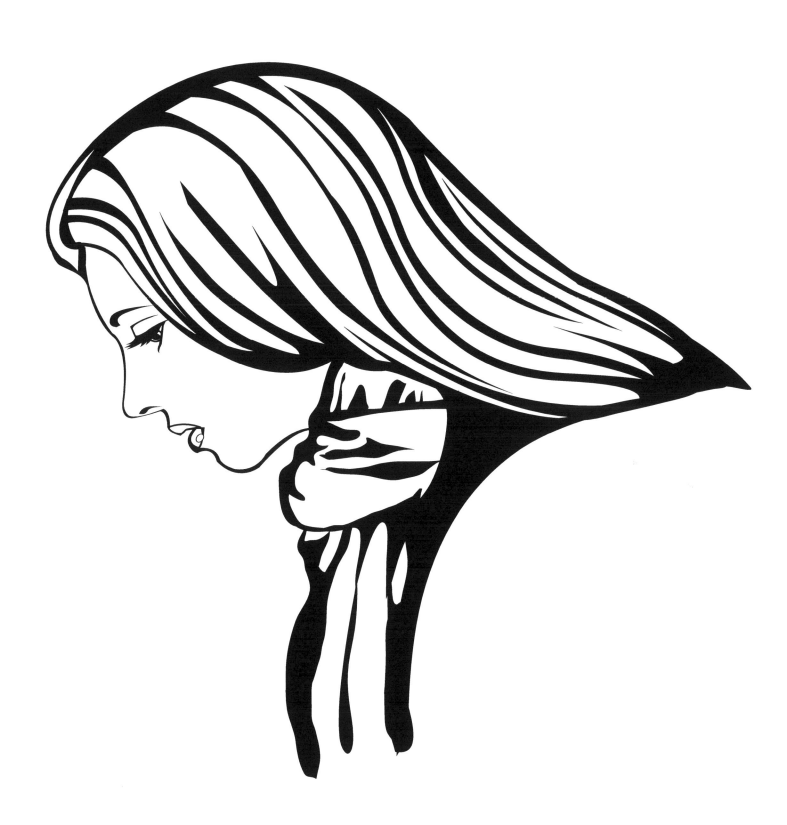

Copyright 2016 Jennifer Kozlansky
Unauthorized reproduction steals from the artist.
Credit **ColoringUniverse.com** when sharing on social media.
Join us on the Coloring Universe Facebook Group!

HAIR

TEXTURE
Hair has a shiny texture, so the trick to making hair look amazing is to be dramatic about the highlights. Plan out areas to leave white and feather in a color that goes darker quickly.

LIGHT SOURCE
Just as with any page, decide where the light source will come from and lightly draw an arrow with a pencil to keep it in mind as you work. Choose shadows and highlights accordingly.

With a shiny texture like hair, the transition between light and dark is almost immediate. After you are finished, remember to go through and 'punch' small areas that would be the very darkest.

Use the diagram below to learn how to plan the darkest, medium, lighter, and lightest areas. Then use the artwork on the next two pages to plan out your own highlight, medium, dark and punch areas.

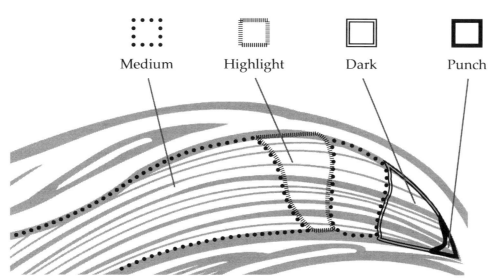

Follow this pattern when coloring hair. Test on the following two pages.

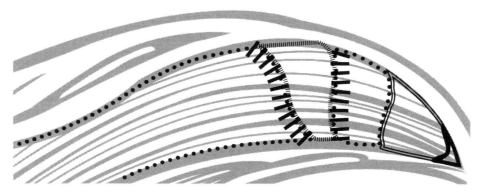

Try this! Blend a very dark section right next to the highlight on one side. In some areas on both sides, being darker on one side. See it as a special *hair punch*... with a little practice, this effect looks awesome.

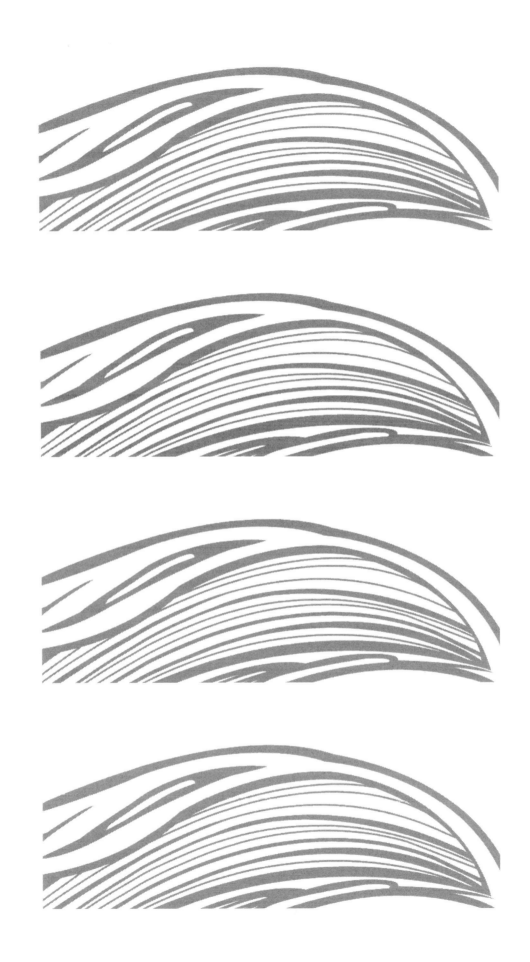

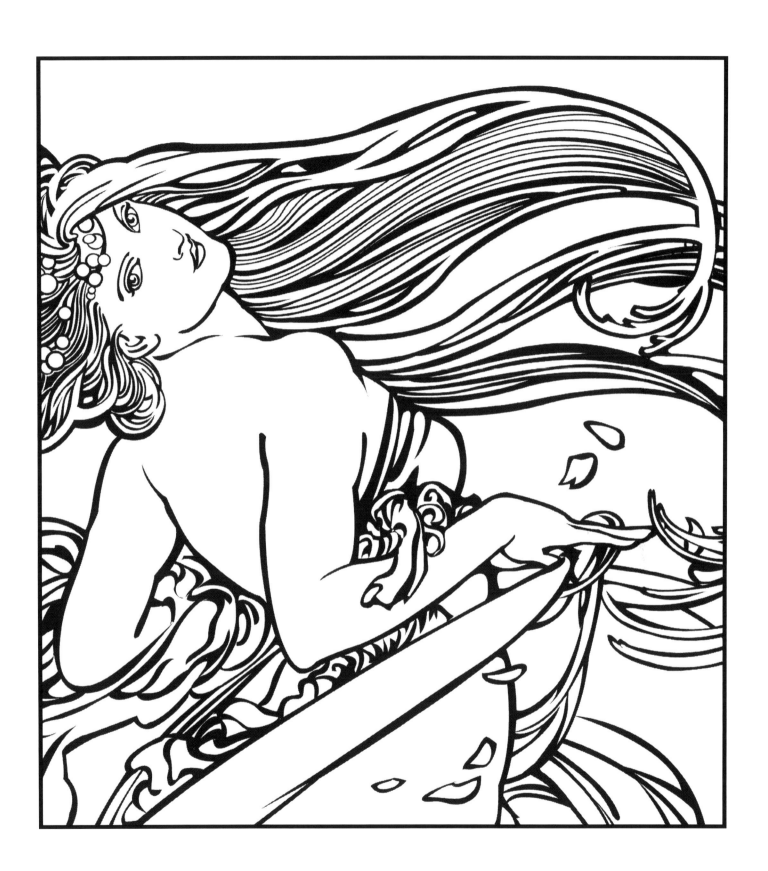

Copyright 2016 Jennifer Kozlansky
Unauthorized reproduction steals from the artist.
Credit **ColoringUniverse.com** when sharing on social media.
Join us on the Coloring Universe Facebook Group!

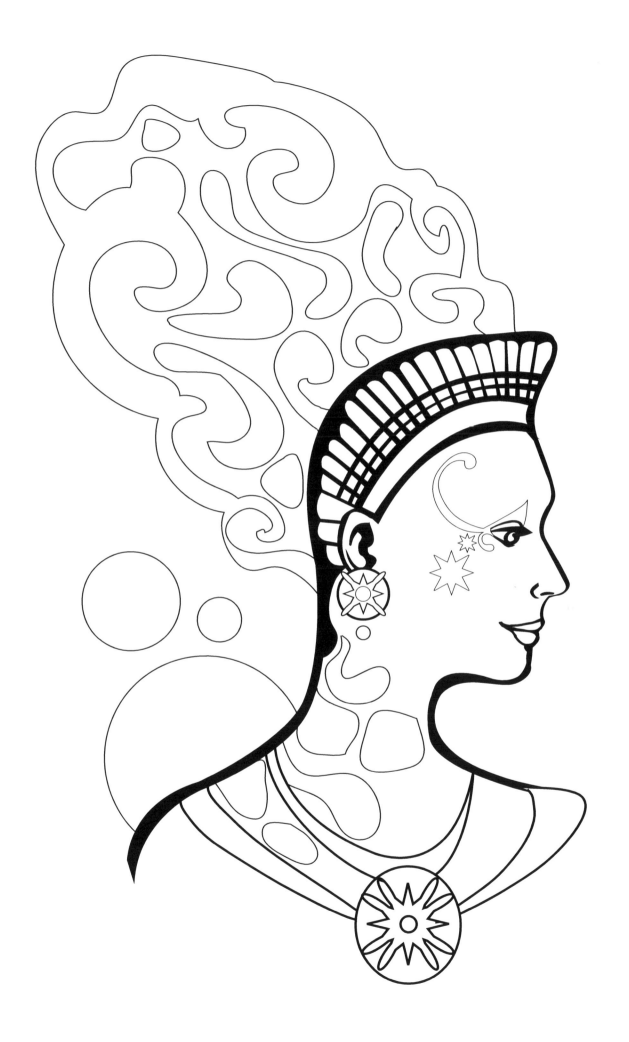

COLORING UNIVERSE

Copyright 2016 Jennifer Kozlansky
Unauthorized reproduction steals from the artist.
Credit **ColoringUniverse.com** when sharing on social media.
Join us on the Coloring Universe Facebook Group!

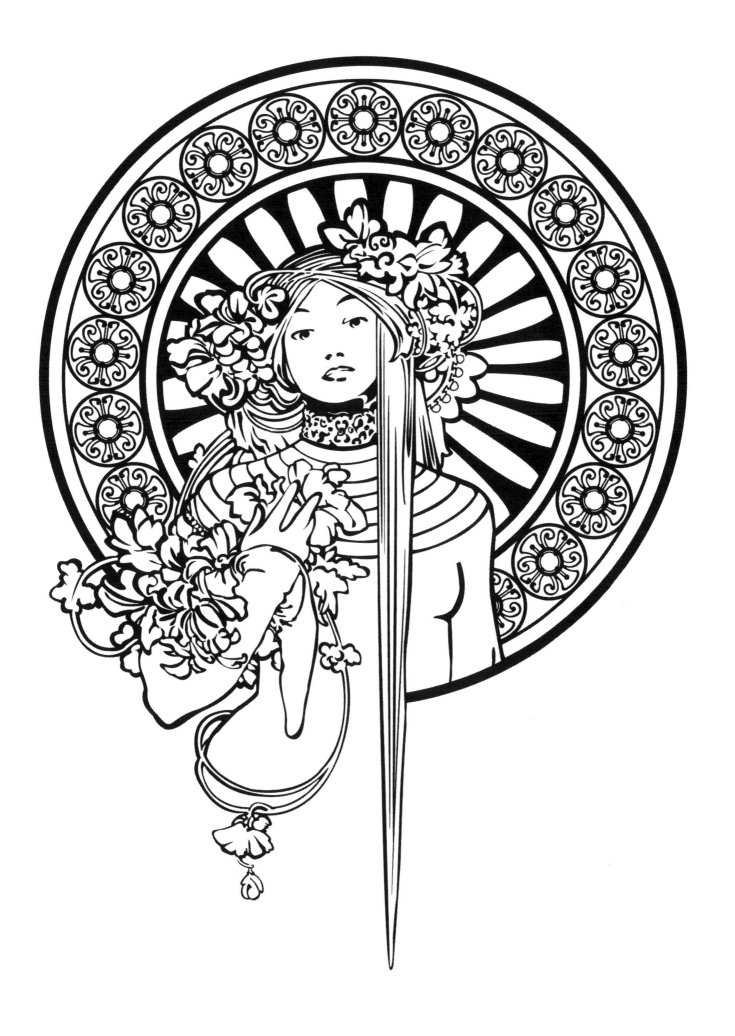

Copyright 2016 Jennifer Kozlansky
Unauthorized reproduction steals from the artist.
Credit **ColoringUniverse.com** when sharing on social media.
Join us on the Coloring Universe Facebook Group!

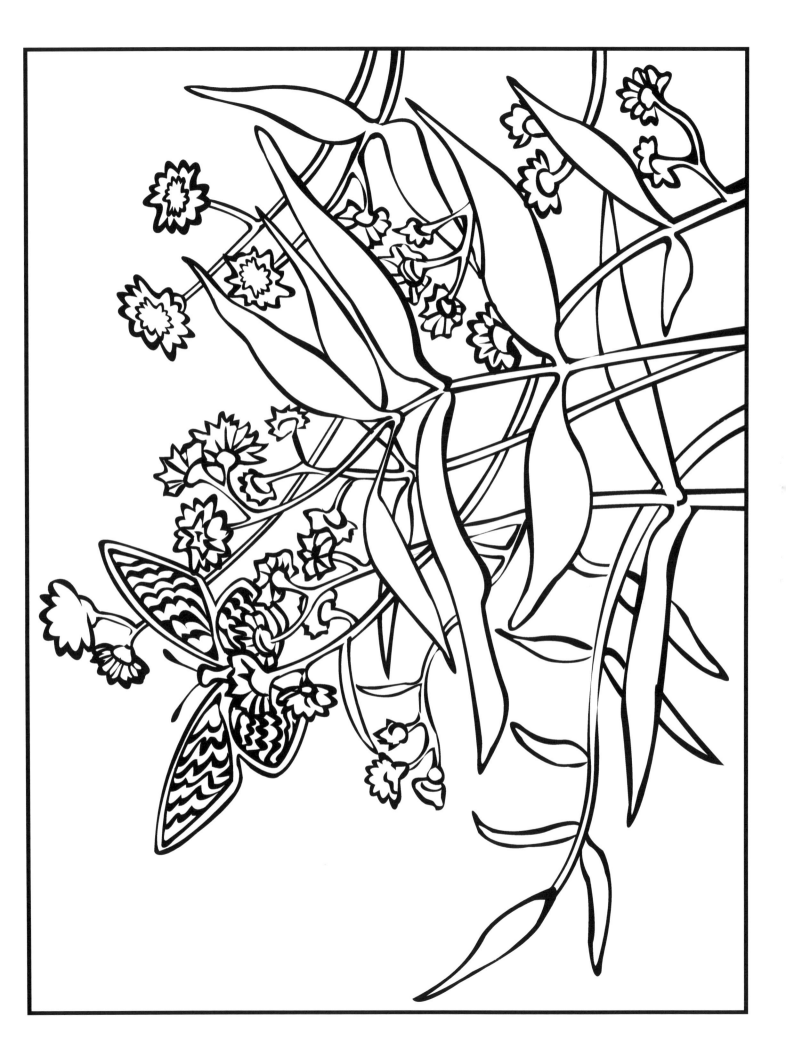

Copyright 2016 Jennifer Kozlansky
Unauthorized reproduction steals from the artist.
Credit **ColoringUniverse.com** when sharing on social media.
Join us on the Coloring Universe Facebook Group!

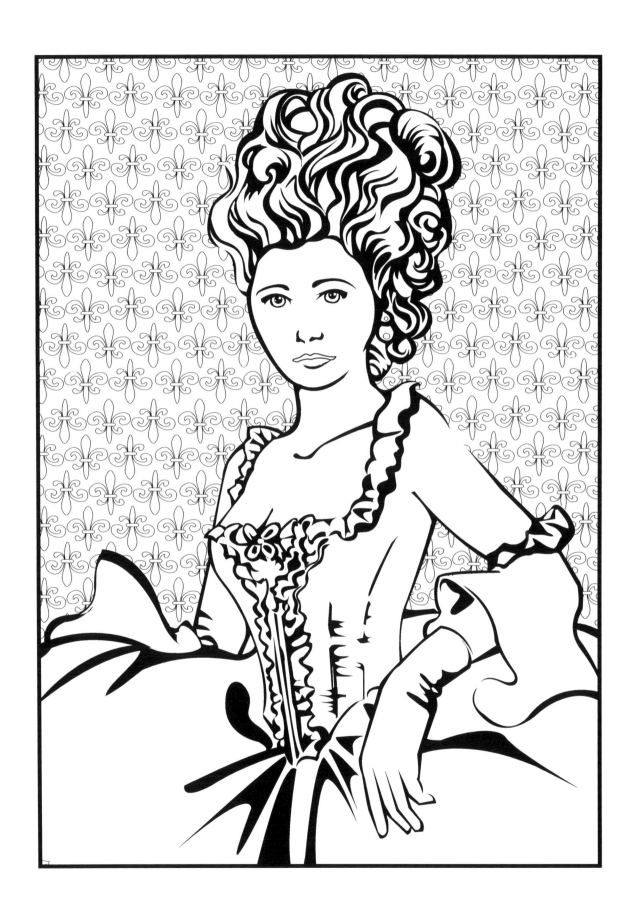

Copyright 2016 Jennifer Kozlansky
Unauthorized reproduction steals from the artist.
Credit **ColoringUniverse.com** when sharing on social media.
Join us on the Coloring Universe Facebook Group!

C OLORING U NIVERSE

Copyright 2016 Jennifer Kozlansky
Unauthorized reproduction steals from the artist.
Credit **ColoringUniverse.com** when sharing on social media.
Join us on the Coloring Universe Facebook Group!

C OLORING U NIVERSE

Copyright 2016 Jennifer Kozlansky
Unauthorized reproduction steals from the artist.
Credit **ColoringUniverse.com** when sharing on social media.
Join us on the Coloring Universe Facebook Group!

This book is dedicated to Benjamin John Dziuba

Made in the USA
Middletown, DE
13 December 2016